By Jonas Ploeger

ALWAYS ONE
BUTTON SHORT

The Buttons of
Edward Gorey

Essay by Kevin McDermott

Pomegranate

PORTLAND, OREGON

Pomegranate Communications, Inc.
19018 NE Portal Way, Portland, OR 97230
800-227-1428 pomegranate.com
sales@pomegranate.com

To learn about our newest titles and special offers from Pomegranate, please visit pomegranate.com
and sign up for our newsletter. For all other queries, see "Contact Us" on our home page.

Library of Congress Control Number: 2021061233
ISBN 978-1-0875-0586-2

Item No. A298

Designed by Cade Hoover
Printed in China

31 30 29 28 27 26 25 24 23 22 10 9 8 7 6 5 4 3 2 1

Dedicated to Edward Bradford

Compiled with the kind help of Edward Bradford, Irwin Terry, David Parry, Robert Greskovic, and Xandy Hand.

A Note on the Contents of This Book

No button collection is ever complete—always one button short. There are, undoubtedly, many other buttons featuring pieces of Edward Gorey's work, but the buttons included in this book were all drawn and designed by Gorey himself.

"O the
of it all!"

BY KEVIN McDERMOTT

CREATING intricate drawings for the
humble pin-back button may seem like an odd pursuit
for an artist to devote much time and effort to, but that's
exactly what Edward Gorey did, and he did it with delight.
The fact that he considered an original button an essential
part of his theatrical productions demonstrates that he
found real joy in these objects of ephemera.

I acquired my first Gorey button from Edward himself, in
the spring of 1985. I was a student in New York University's
undergraduate drama department and was luckily cast in a new,
original musical of published and unpublished works written by Edward.
The show was called *Tinned Lettuce*. Edward designed the sets
and costumes and—with his unapologetic, infectious laugh—was
physically present at rehearsals during development of the show.

7

"As I walked around campus and New York City with that backpack, the button was doing what pin-back buttons are intended to do. They tell the world whose team we're on."

That rehearsal period was one of the most fun times in my life. And then one evening, during dress rehearsals, cast members were each presented with their own *Tinned Lettuce* button. It was adorable. I loved it and immediately pinned it on my backpack.

As I walked around campus and New York City with that backpack, the button was doing what pin-back buttons are intended to do. They tell the world whose team we're on. Each button communicates whatever cause, political candidate, affiliation, or even product we choose to support and advertise. Wearing a button on our person is a validation of its tiny message. We are literally walking billboards. I was, of course, pleased with the surreptitious nature of this *Tinned Lettuce* button and was all too happy to fill people in on what it was about, if they had the inquisitive imperative to ask.

The history of the pin-back button can be traced to 1787, when a member of the Wedgwood pottery dynasty produced a porcelain antislavery medallion that included an image and a slogan. Some cite this as a forerunner of today's political campaign buttons. Early campaign pins were worn as pendants or sewn to a lapel. Even George Washington's supporters were known to wear these. In 1893, Benjamin S. Whitehead patented a design that placed a sheet of transparent celluloid film over a badge in order to protect the image from wear and tear. Then, in 1896, another patent was granted to George B. Adams of Whitehead & Hoag Co. for "useful

Improvements in Badge Pins or Buttons," a version that used a metal pin built into the reverse side of the button. Over the years, slight alterations and improvements (open or closed back) were made by various inventors, but this was the same basic concept as the buttons Edward used.

> "Wearing a button
> on our person is a
> validation of its
> tiny message."

Having worked with Edward on various theater productions, I'm sure there were a few aspects about the medium that amused him. Firstly, physical restrictions are imposed when designing a button. There is limited space in which to express oneself and make a visually arresting image— in Edward's case, a circle slightly over two inches in diameter. With the *Tinned Lettuce* button, a young boy in a sailor suit is shown running away from an oversized tin of lettuce, which could easily be mistaken for an apocalyptic mushroom cloud.

Edward preferred working on a small scale overall. In terms of dimensions, his books were on the modest side. He even created a couple of miniature books that are just a bit larger than a standard US postage stamp. It is rare to find a large-scale drawing by Edward. Clarifying his thoughts to the measurements of that small "canvas" must have felt like an enticing challenge to him.

There is also the nostalgic nature of a pin-back button. Like postcards, another medium beloved by Edward, buttons recall an earlier era. This simple object removes most of the complex connotations of communication and advertising now held as essential. Although print ads have long had a place in advertising, today companies also spend millions of dollars to bombard us on television and the internet with thirty- or sixty-second ads to get their message out. The button calls to mind a time before electricity was yet tamed, a time when advertising goals were often met in less expensive, less complicated ways, a time well before today's wired world of social media. Edward's buttons nod to the greatest form of advertising— word of mouth.

A button's communication is both active and passive. Active for artist and recipient in choosing a cause or product to promote, as well as in the act of attaching that button to one's jacket, hat, or backpack. And passive in simply wearing it and letting the button's illustration and text do its communicative work. No doubt Edward was tickled by that.

"O the of it all" was the mysterious message on Edward's button for the opening night of his Broadway musical, *Gorey Stories*. The show lasted for only one performance on the Great White Way, unfortunately having opened during a major newspaper strike in New York. In 1978, newspaper reviews were essential to ticket sales, and with no reviews being printed, the producers decided to close the show. And yet, this exuberant exclamation nicely describes the buttons made by Edward. O how lucky we are to see and enjoy them today.

—Kevin McDermott

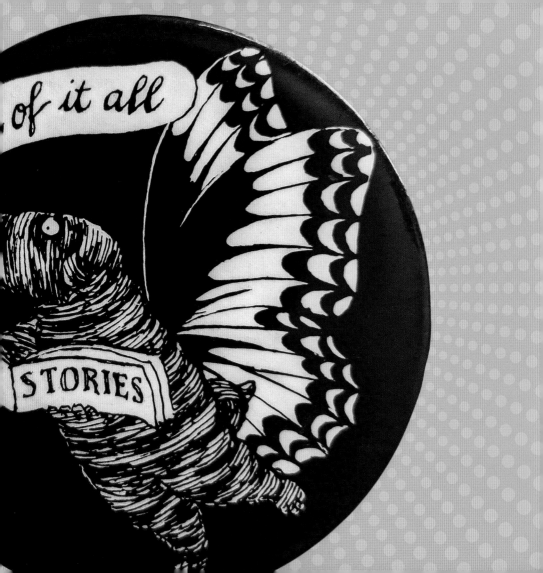

The
Shows

The buttons featured debuted for the following shows:

Amphigorey: A Musicale, April 9–May 22, 1994
Blithering Christmas, December 3–5,10–12, 17–19, 1992
Chinese Gossip, July 14–16, 21–23, 28–30, August 4–5, 1994
Crazed Teacups, July 23–26, July 30–August 2, August 6–9, 1992
English Soup, October 2–4, 9–11, 16–18, 23–25, 1998
Epistolary Play, July 25–August 30, 1997
Flapping Ankles, July 18–21, 25–28, August 1–4, 8–11, 1991
Folded Napkin, The, 1987
Gorey Stories, October 30, 1978
Inverted Commas, July 6–8, 13–15, 20–22, 27–29, 1995
Lost Shoelaces, August 13–16, 20–23, 1987
Omlet: or, Poopies Dallying / Rune lousse, rune de leglets:
 ou, sirence de glenouirres (puppets), July 25–26, August 8–9, 1998
Stuffed Elephants, August 17–19, 24–26, August 31–September 2, 1990
Stumbling Christmas, November 30, December 7, 14, 21, 1995
Tinned Lettuce: or, The New Musical, April 17–27, 1985
Tragic Secrets, 1996
 [Due to an actor's illness, this show was not performed.]
Tschaikovsky Festival, June 5–14, 1981
Useful Urns, June 28–July 1, July 4, 5–8, 12–15, August 16–19, 1990

The
Buttons

New York City Ballet[1] ... 18 – 26
New York City Ballet – Tschaikovsky Festival[2]............ 27
New York City Ballet – Kitty Ballet[3] 28 – 30
Gorey Stories ... 31 – 32
Tinned Lettuce ...33
Lost Shoelaces ... 34
The Folded Napkin[4] ... 35 – 45
Don't Judge a Bork by His Cover[5] 46
Stuffed Elephants ... 47
Useful Urns ... 48
Flapping Ankles ... 49
Crazed Teacups ... 50
Blithering Christmas 51
Amphigorey: A Musicale[6] ... 52
Chinese Gossip ... 53
Inverted Commas ... 54
Stumbling Christmas 55
Tragic Secrets[7] ... 56
Epistolary Play ... 57
Embrace Etceterism[8] 58
English Soup ... 59

Endnotes ... 62

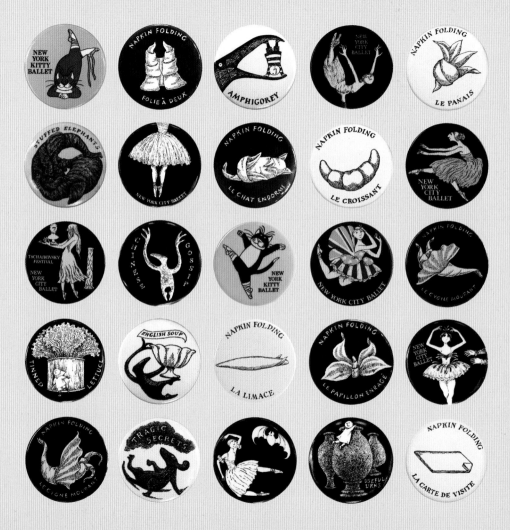

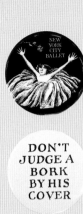

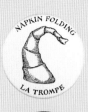
NAPKIN FOLDING
LA TROMPE

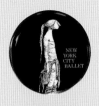
NEW YORK CITY BALLET

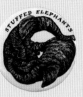
STUFFED ELEPHANTS

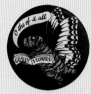
O she of it all
GOREY STORIES

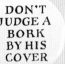
DON'T JUDGE A BORK BY HIS COVER

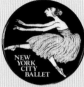
NEW YORK CITY BALLET

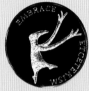
EMBRACE EXCENTRISM

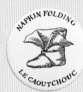
NAPKIN FOLDING
LE CAOUTCHOUC

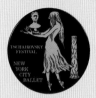
TSCHAIKOVSKY FESTIVAL
NEW YORK CITY BALLET

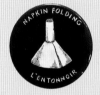
NAPKIN FOLDING
L'ENTONNOIR

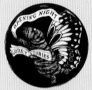
OPENING NIGHT
GOREY STORIES

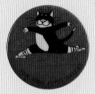

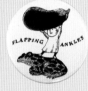
FLAPPING ANKLES

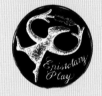
Epistolary Play

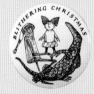
BLITHERING CHRISTMAS

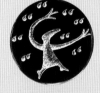

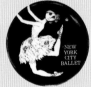
NEW YORK CITY BALLET

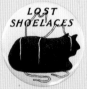
LOST SHOELACES

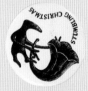
STUMBLING CHRISTMAS

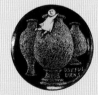
USEFUL URNS

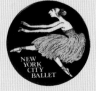
NEW YORK CITY BALLET

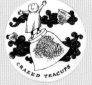
CRAZED TEACUPS

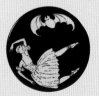

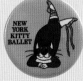
NEW YORK KITTY BALLET

1974

New York City Ballet

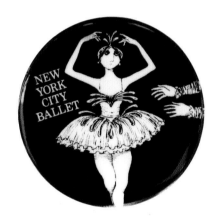

New York City Ballet

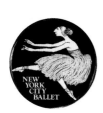
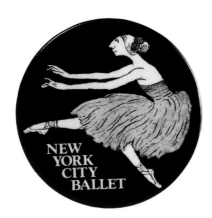
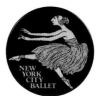

1974

New York City Ballet

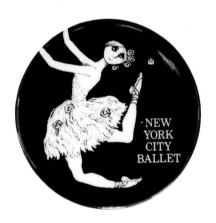

New York City Ballet

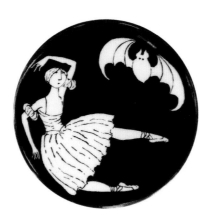

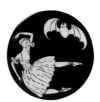

1975

New York City Ballet

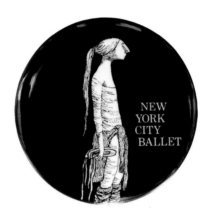

NEW
YORK
CITY
BALLET

New York City Ballet

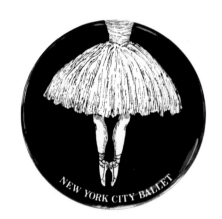

1975

New York City Ballet

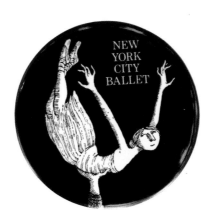

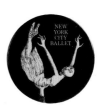

New York City Ballet

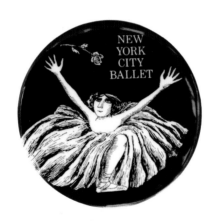

1979

New York City Ballet

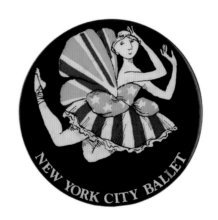

New York City Ballet – Tschaikovsky Festival

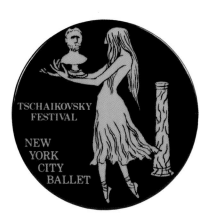

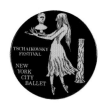

1974

New York City Ballet – Kitty Ballet

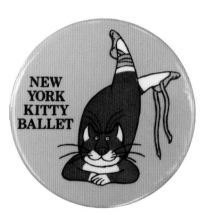

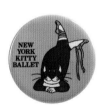

New York City Ballet – Kitty Ballet

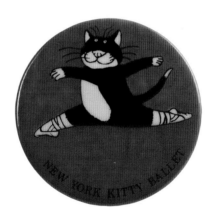

1974

New York City Ballet – Kitty Ballet

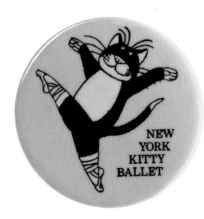

Gorey Stories – Opening Night

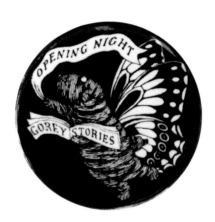

1978

Gorey Stories – O the of it all

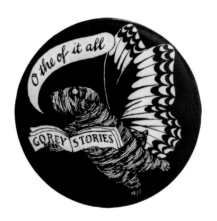

Tinned Lettuce

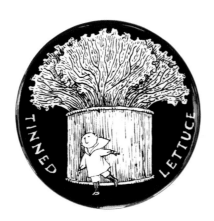

1987

Lost Shoelaces

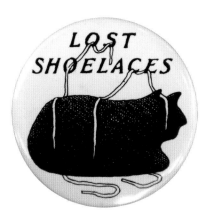

The Folded Napkin – La Carte de Visite

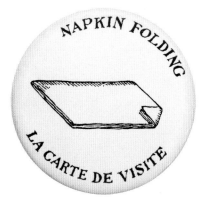

1987

The Folded Napkin – La Trompe

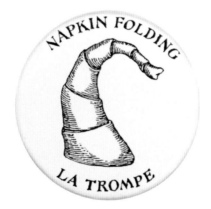

The Folded Napkin – Le Caoutchouc

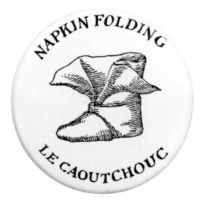

1987

The Folded Napkin – Le Croissant

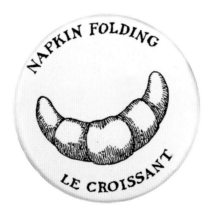

The Folded Napkin – Le Panais

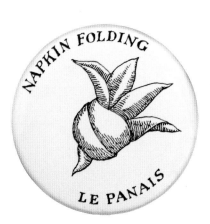

1987

The Folded Napkin – La Limace

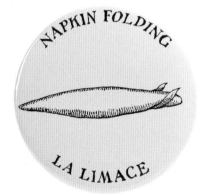

The Folded Napkin – Le Chat Endormi

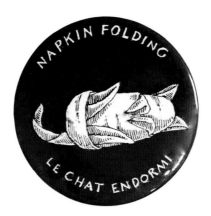

1987

The Folded Napkin – Folie à Deux

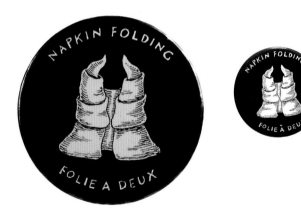

1987

The Folded Napkin – L'Entonnoir

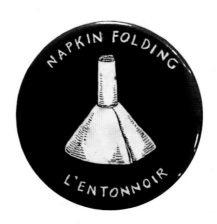

1987

The Folded Napkin – Le Papillon Enragé

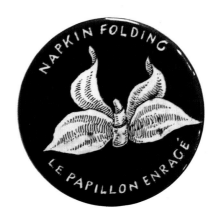

The Folded Napkin – Le Cygne Mourant

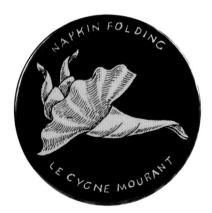

Don't Judge a Bork by His Cover

DON'T
JUDGE A
BORK
BY HIS
COVER

1990

Stuffed Elephants

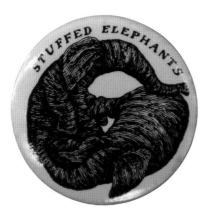

1990

Useful Urns

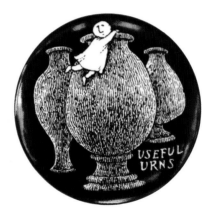

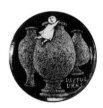

1991

Flapping Ankles

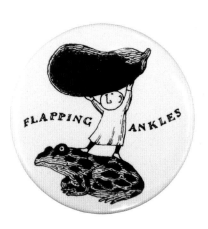

1992

Crazed Teacups

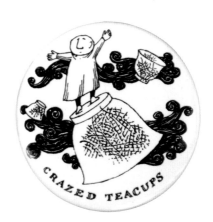

Blithering Christmas

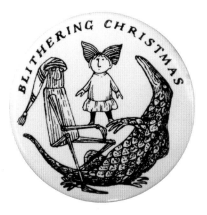

1994

Amphigorey: A Musicale

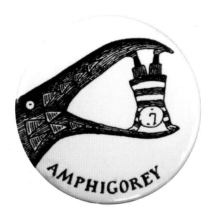

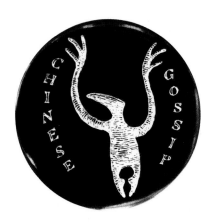

1995

Inverted Commas

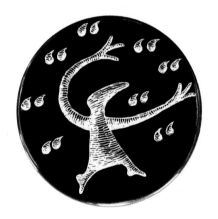

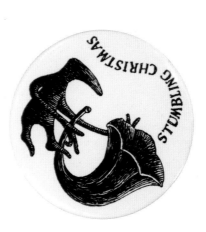

STUMBLING CHRISTMAS

1996

Tragic Secrets

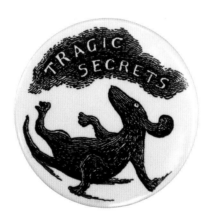

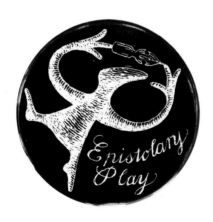

c. 1998

Embrace Etceterism

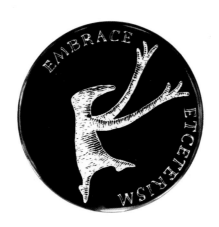

1998

English Soup

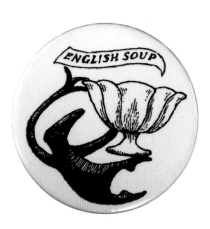

Edward's butto

greatest form

—word of m u

"

KEVIN McDERMOTT

ns nod to the
of advertising
th.

Endnotes

[1] Series button text: New York City Ballet
The author has heard of a "ballerina with bat" button (page 21) that includes
New York City Ballet on its front, but he has been unable to locate one.
Always one button short...

[2] Button text: New York City Ballet – Tschaikovsky Festival, 1981
Gorey's spelling of "Tschaikovsky" here matches that preferred by the New York
City Ballet and the choreographer George Balanchine. They chose that version over
the more common "Tchaikovsky" because it's how the composer transliterated his name
when he visited New York in 1891.

[3] Button text: **New York Kitty Ballet**, 1974
These designs combined two of Gorey's great loves—the New York City Ballet and cats.

[4] Series button text: Napkin Folding (plus individual French subtitles)
This button series was created for *The Folded Napkin*, 1987, a silent skit.

[5] Button text: Don't Judge a Bork by His Cover, 1987
Unlike the other buttons in this book, which were all made for ballet or play
performances, this button was likely about Judge Robert Bork, who was nominated
to the US Supreme Court in 1987. As Bork was a conservative judge with originalist views,
many were concerned that his nomination would threaten civil and women's rights.

[6] Button text: *Amphigorey*, 1994
Amphigorey: A Musicale was a reworking of *Tinned Lettuce*. It would again be revised
as the play *The Gorey Details*, which was in production when Gorey died, and
premiered posthumously.

[7] Button text: *Tragic Secrets*, 1996
Due to an actor's illness, this show was not performed.

[8] Button text: Embrace Etceterism, c. 1998
Gorey referred to the many theater productions performed at Cape Cod, Massachusetts,
as "entertainments" (and later as "etceterist entertainments"). This button was
produced for one such performance, likely *Omlet: or, Poopies Dallying / Rune lousse,
rune de leglets: ou, sirence de glenouirres*, 1998.

About the Contributors

German author, publisher, and photographer **Jonas Ploeger** likes to say, "Expect the unexpected!" Edward Gorey would surely agree. Ploeger is an avid collector of everything Gorey, and among his prized pieces are pin-back buttons, stuffed creatures, and books from around the world. Ploeger's fine photographs are featured in this book.

EXPECT THE UNEXPECTED!
–JP

Kevin McDermott met Edward Gorey in 1985 as an acting student at New York University performing in the premier production of Gorey's *Tinned Lettuce*. He has worked as an actor, producer (producing two of Gorey's shows off Broadway), graphic designer, and photographer. He has also helped maintain the Edward Gorey archive. He is the author of *Elephant House; or, The Home of Edward Gorey* and lives in Palm Springs, California.

O the of it all